Moonstone Press

Project Editor: Stephanie Maze
Art Director: Alexandra Littlehales
Senior Editor: Rebecca Barns

PHOTOGRAPHY: Front Cover: © 2002 Medford Taylor/National Geographic Image Collection;
Back Cover: © 2002 Michael Fogden/DRK Photo; © 2002 Frans Lanting/Minden Pictures;
© 2002 Flip Nicklin/Minden Pictures; © 2002 Medford Taylor/National Geographic Image Collection;
© 2002 Jack Wilburn/Animals Animals; © 2002 Michio Hoshino/Minden Pictures;
© 2002 Frans Lanting/Minden Pictures; © 2002 Belinda Wright/DRK Photo;
© 2002 Fred Bavendam/Minden Pictures; © 2002 John Cancalosi/DRK Photo;
© 2002 Fabio Colombini/Animals Animals; © 2002 Frans Lanting/Minden Pictures;
© 2002 Fred Bavendam/Minden Pictures; © 2002 Frans Lanting/Minden Pictures;
© 2002 Michael Fogden/DRK Photo; © 2002 Frans Lanting/Minden Pictures.

ISBN 0-9707768-7-X
Library of Congress Cataloging-in-Publication Data
Beautiful moments in the wild : animals and their colors.--1st ed.
p.cm.--(Moments in the wild; 4)
Summary: Introduces colors found in nature through photographs of, and simple text about, such
diverse animals as a pink flamingo, a purple sea star, a yellow caterpillar, and a brown impala.
1. Color of animals--Juvenile literature. [1. Color of animals. 2. Animals.] I. Series.
QL767 .B38 2002
590-dc21 2001059245

First edition
10 9 8 7 6 5 4 3 2 1

Printed in Singapore

Beautiful Moments
In the Wild

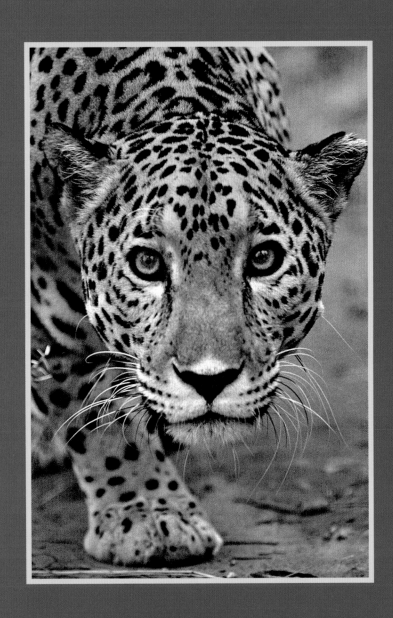

Animals and Their Colors

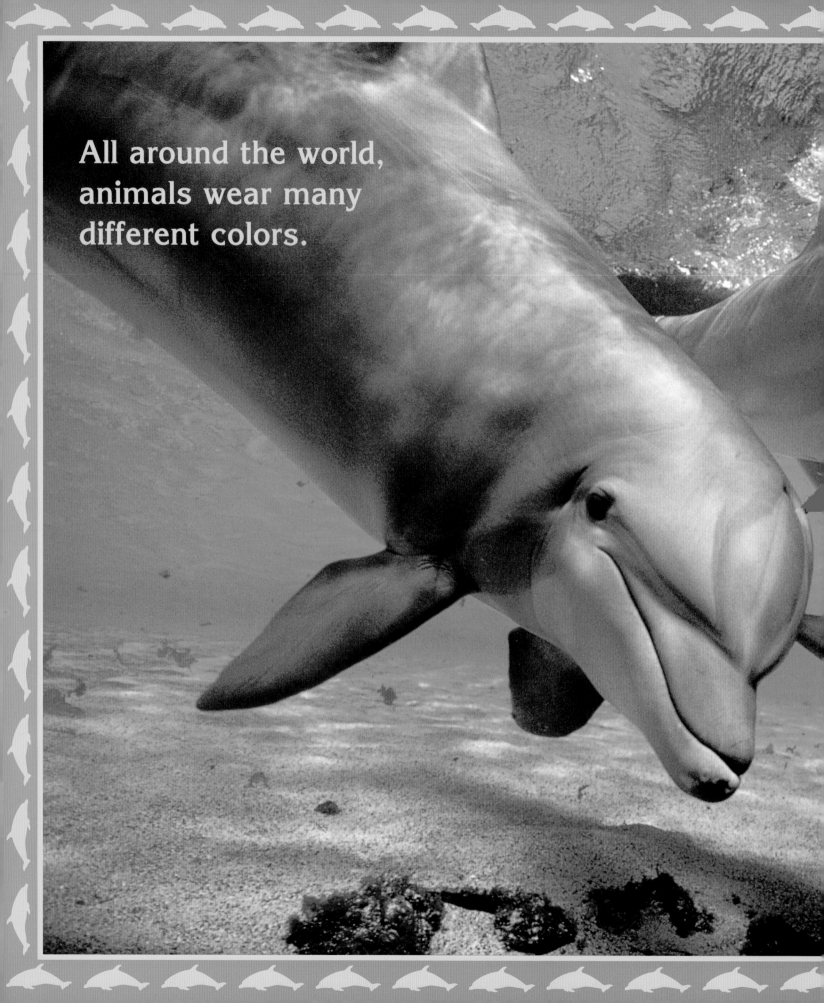

All around the world,
animals wear many
different colors.

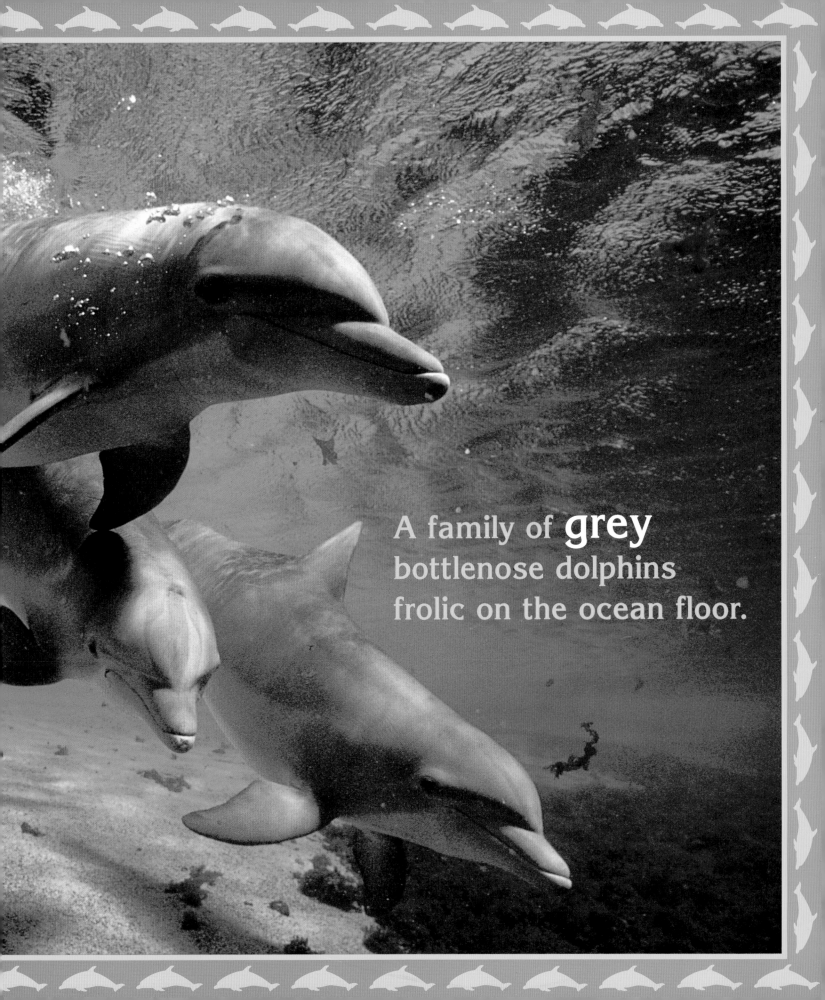

A family of **grey** bottlenose dolphins frolic on the ocean floor.

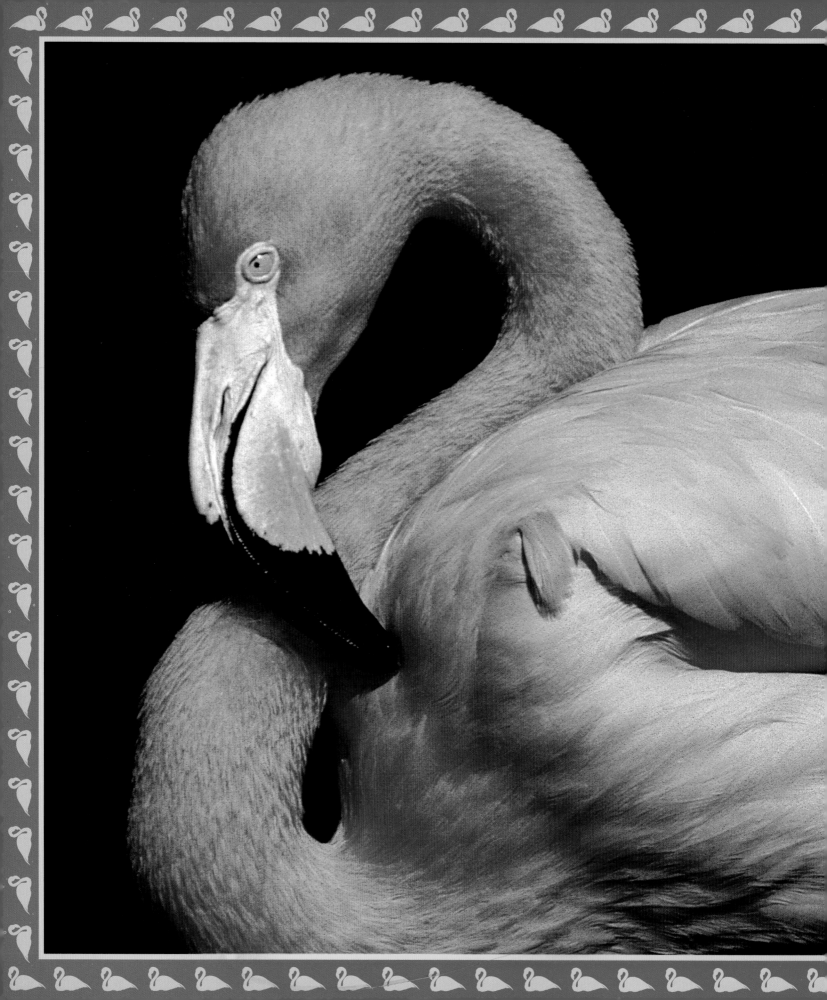

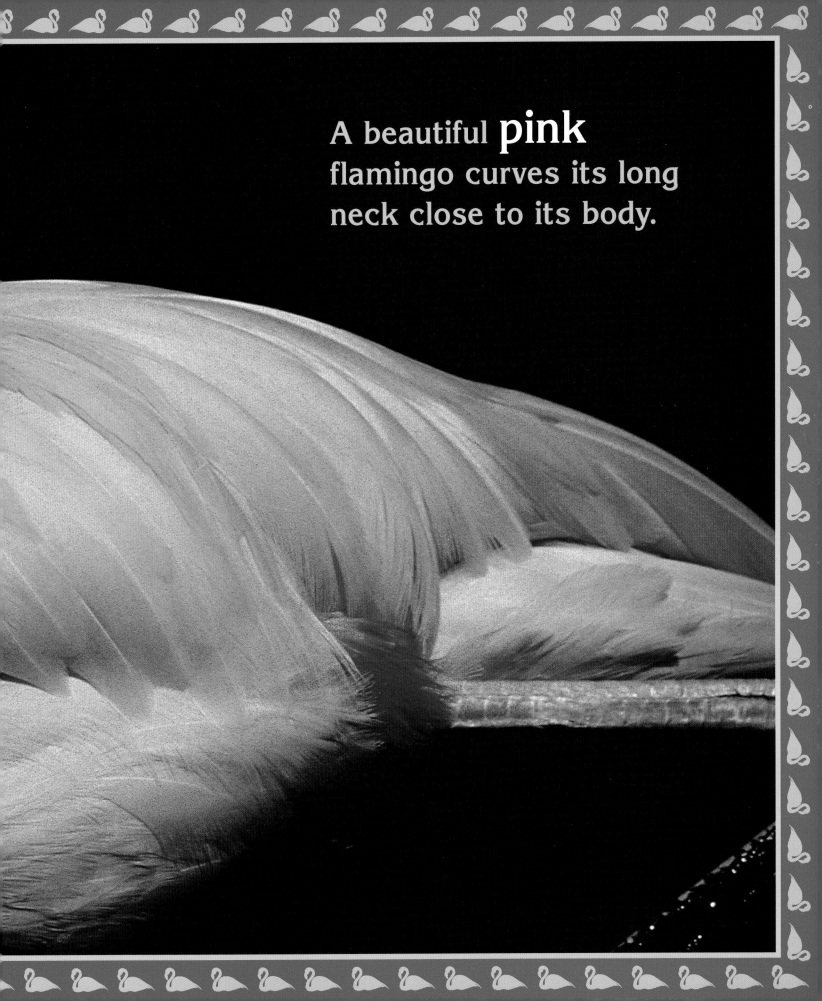

A beautiful **pink** flamingo curves its long neck close to its body.

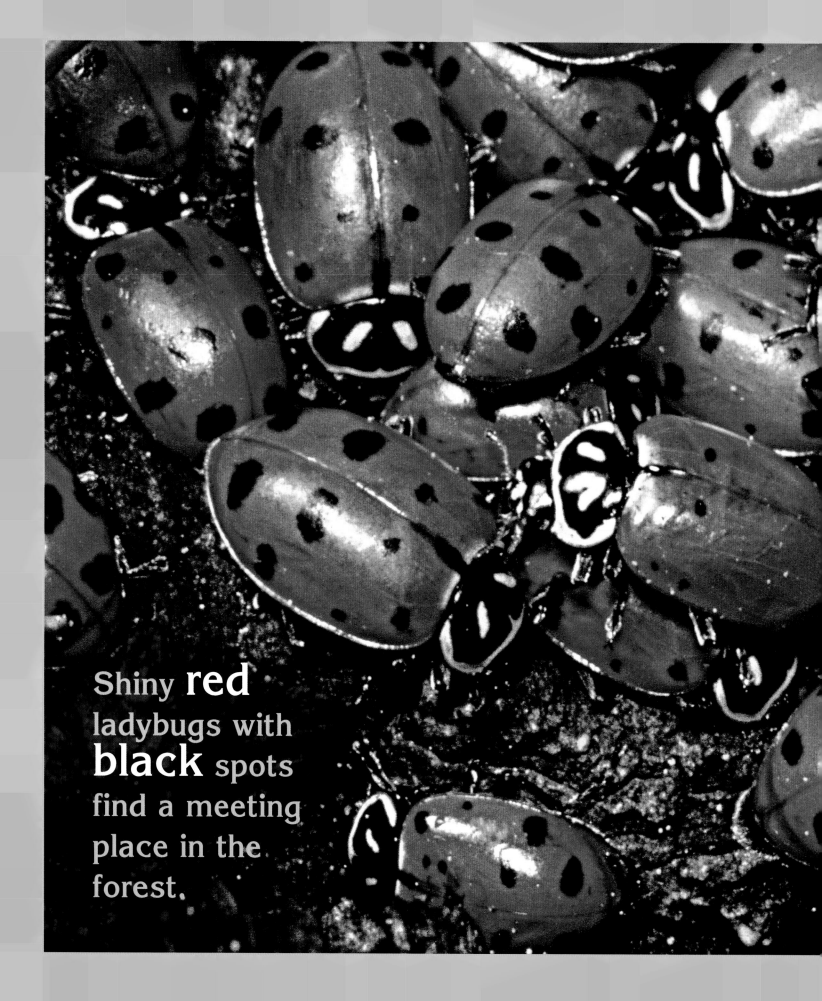

Shiny **red** ladybugs with **black** spots find a meeting place in the forest.

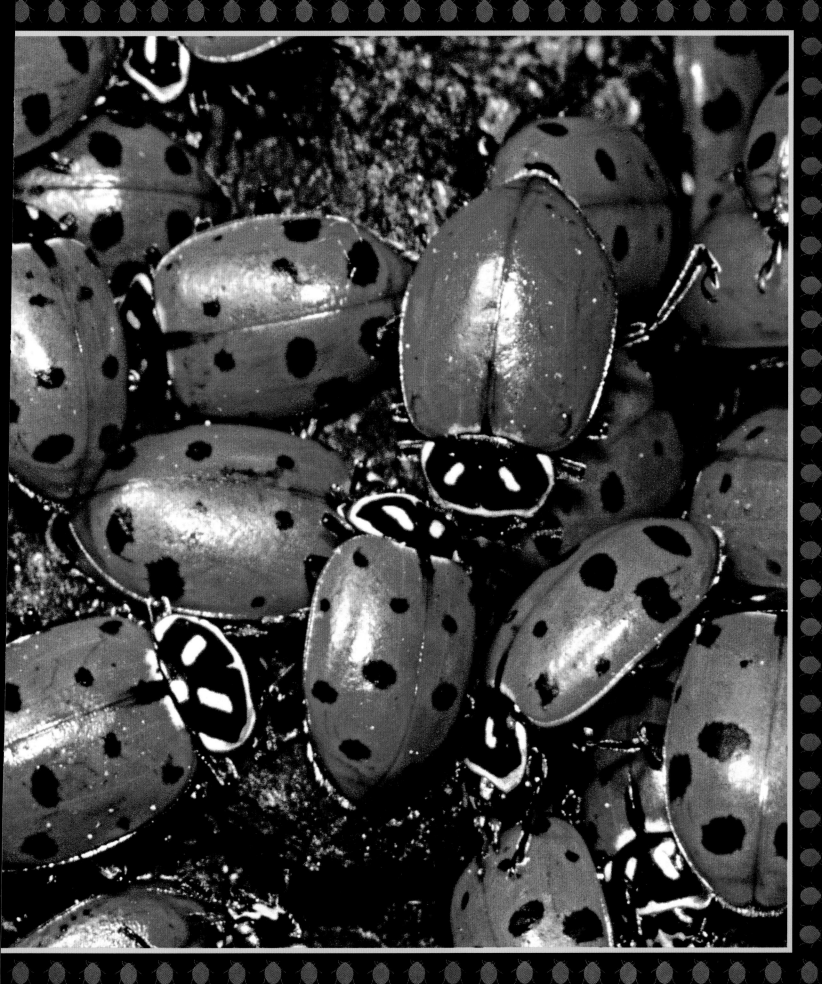

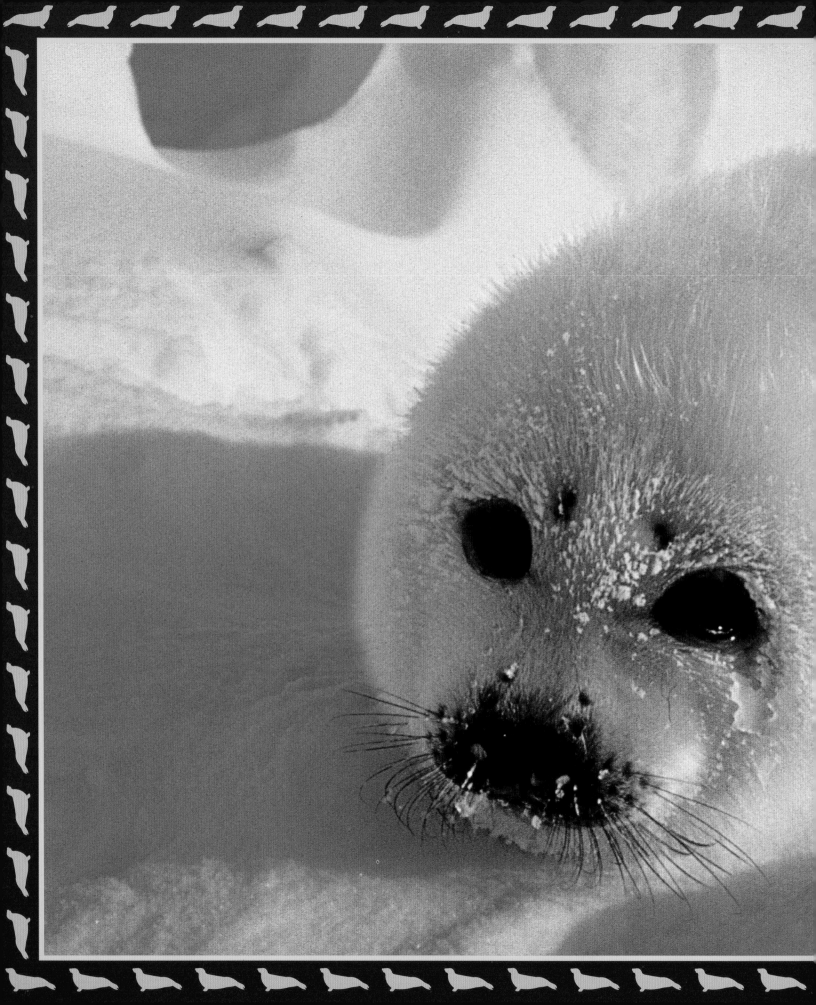

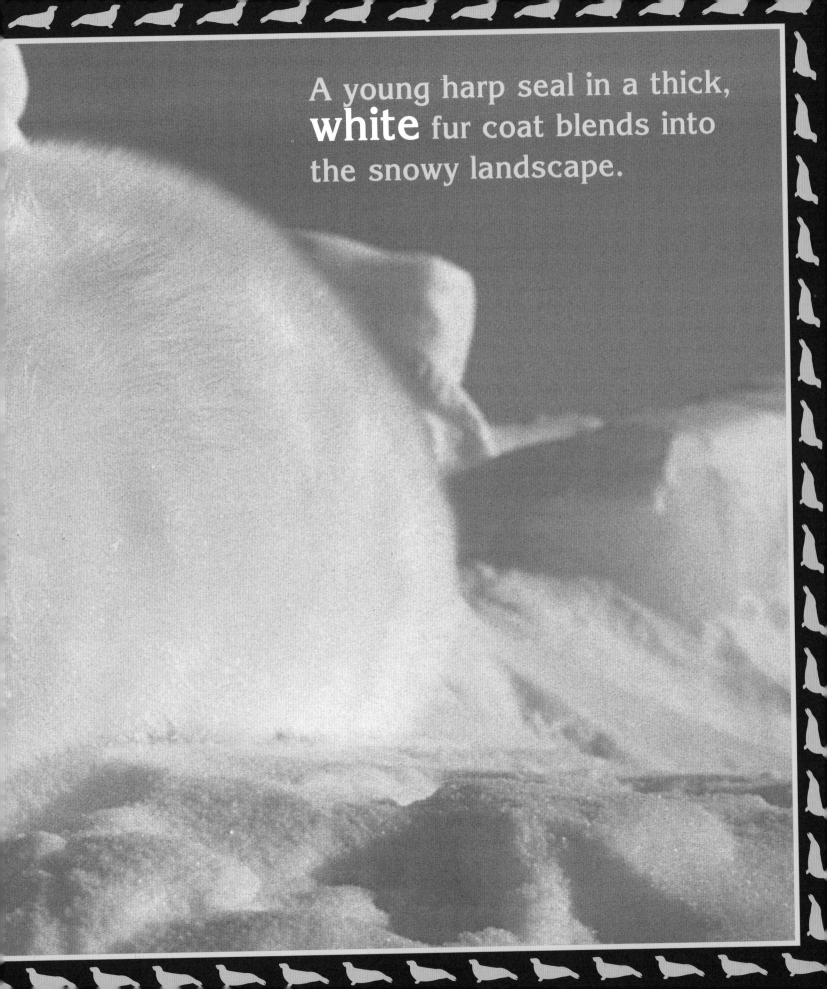

A young harp seal in a thick, **white** fur coat blends into the snowy landscape.

A thirsty herd of **brown** impalas line up to drink at a water hole.

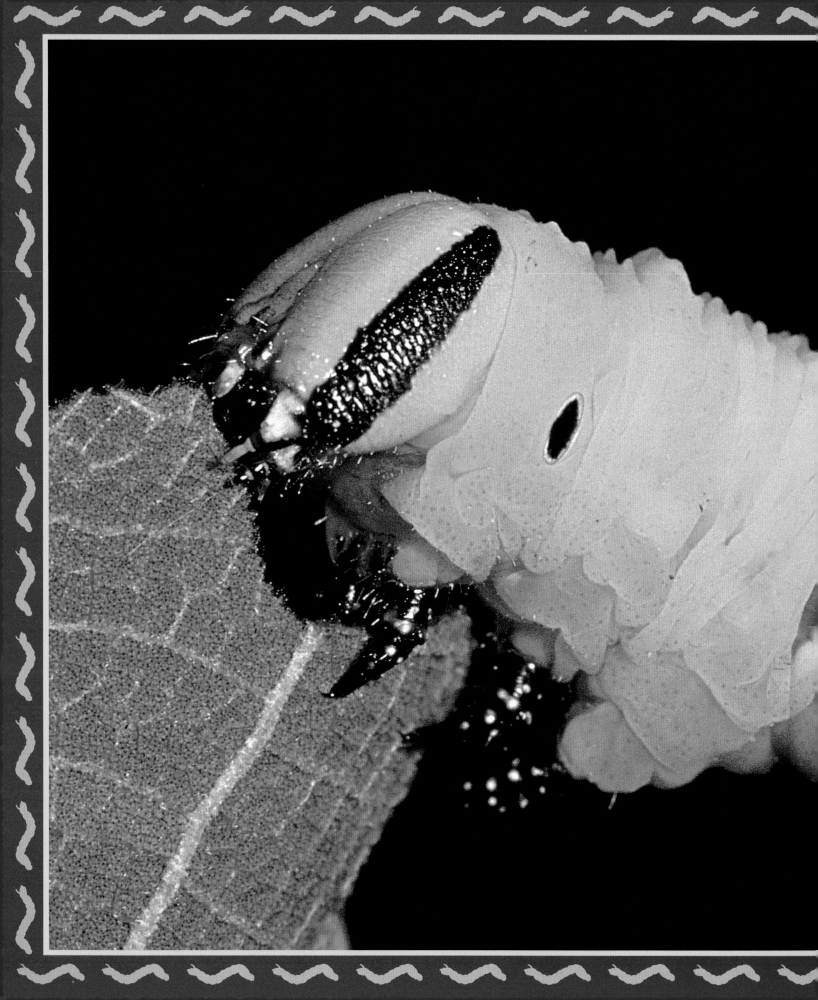

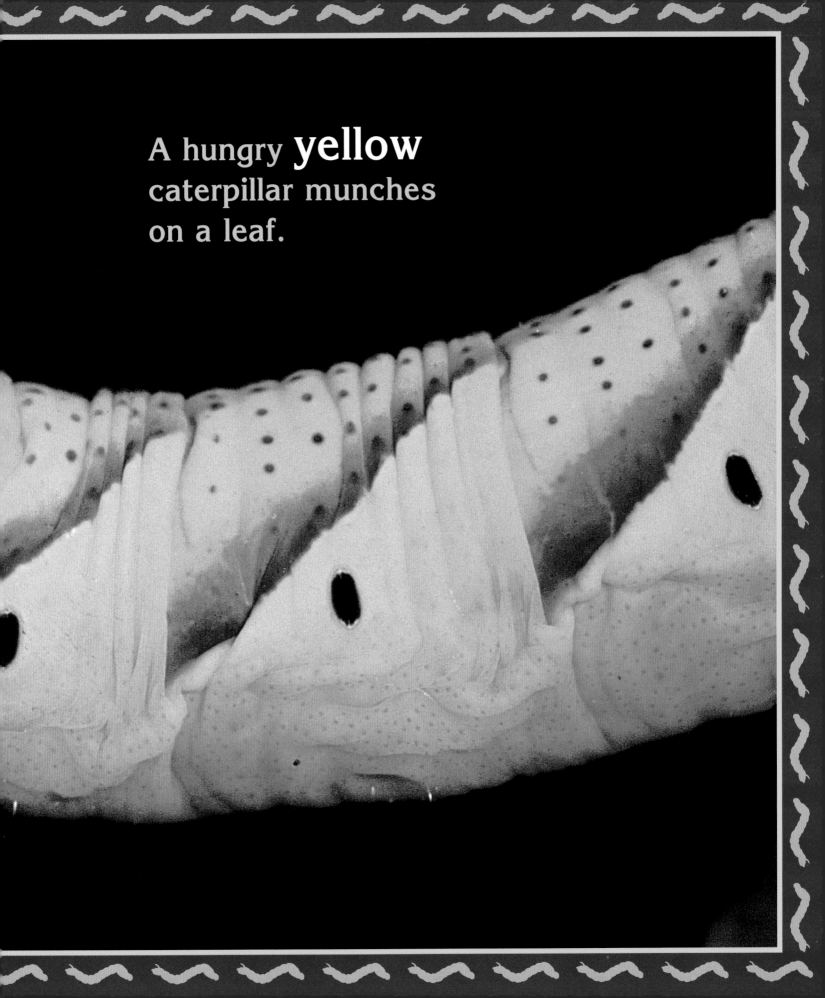

A hungry **yellow** caterpillar munches on a leaf.

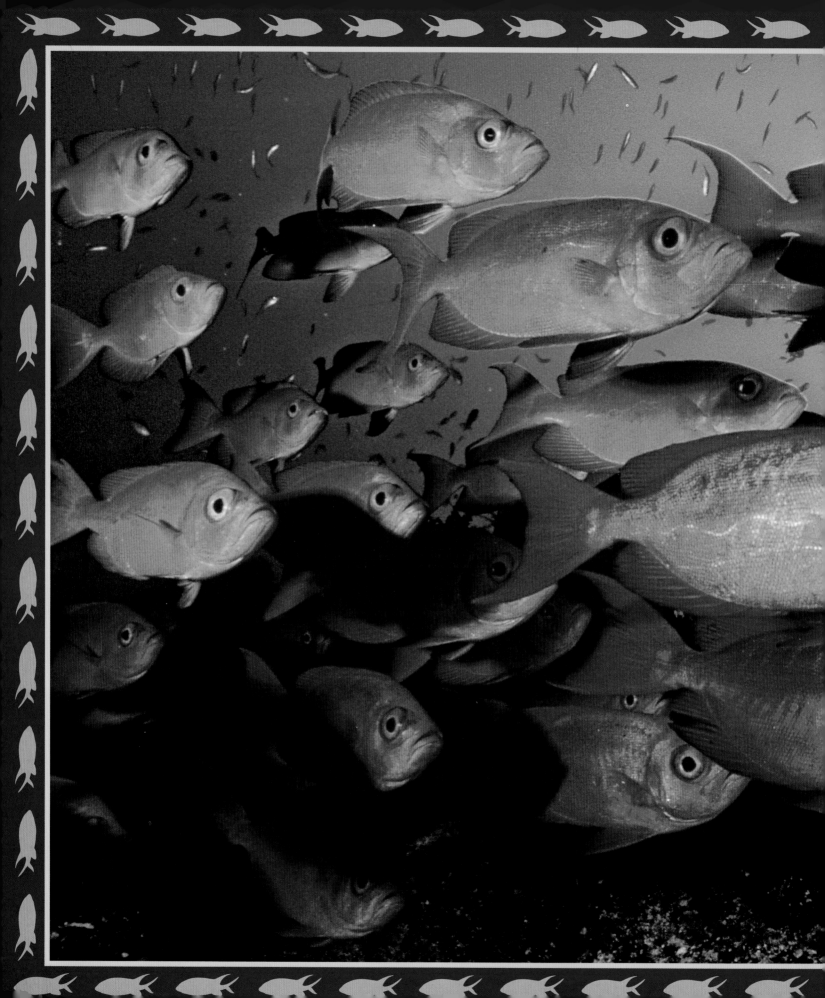

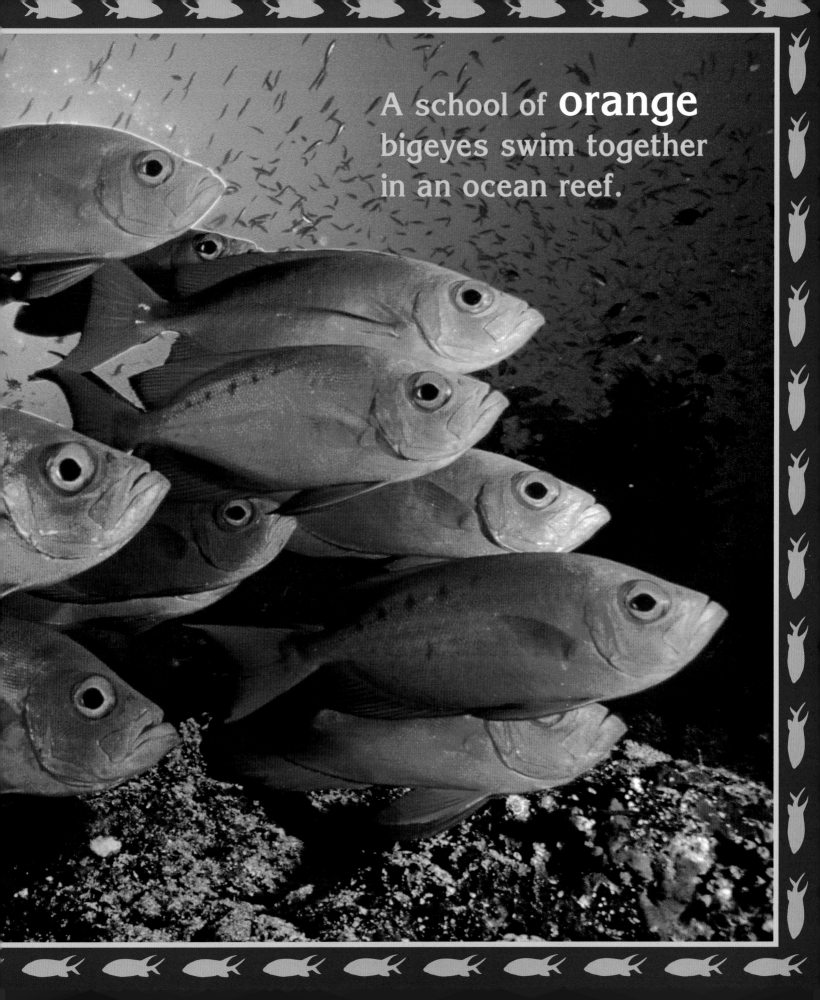

A school of **orange** bigeyes swim together in an ocean reef.

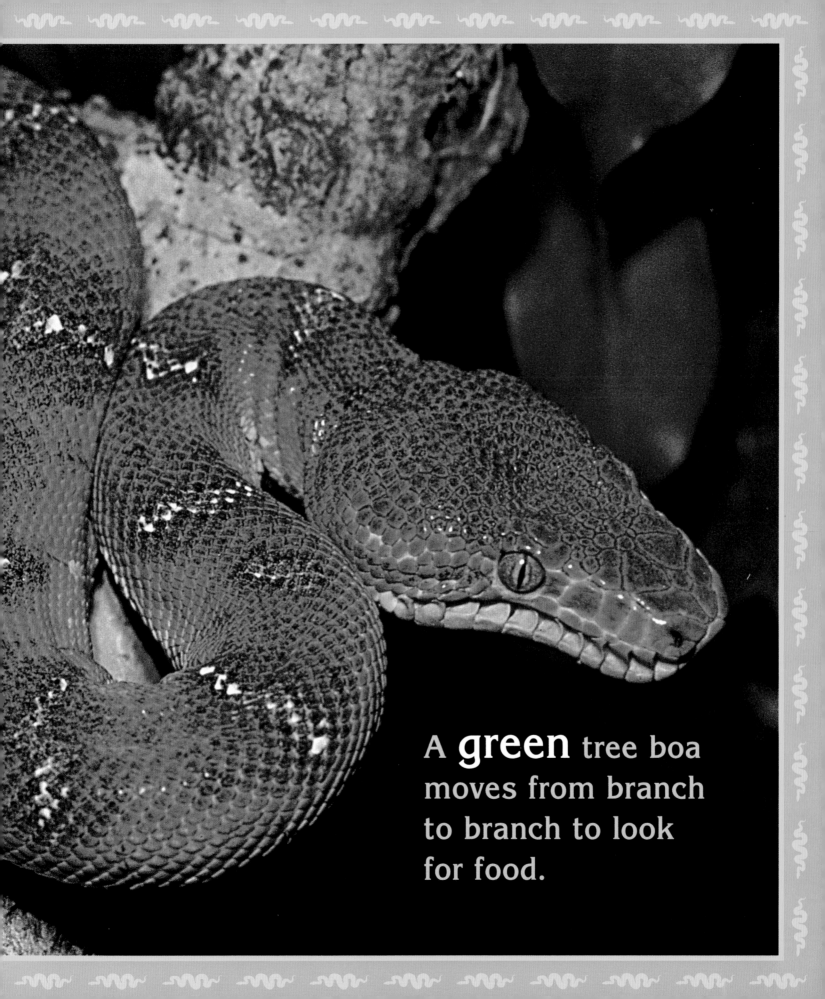

A **green** tree boa
moves from branch
to branch to look
for food.

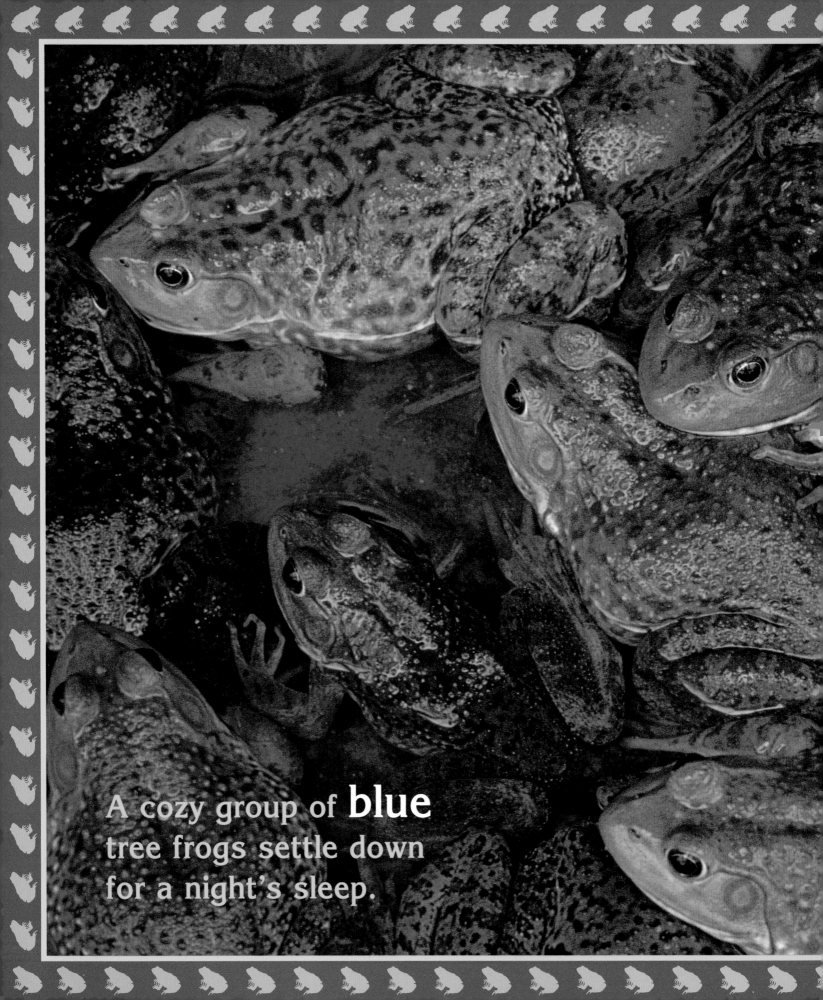

A cozy group of **blue** tree frogs settle down for a night's sleep.

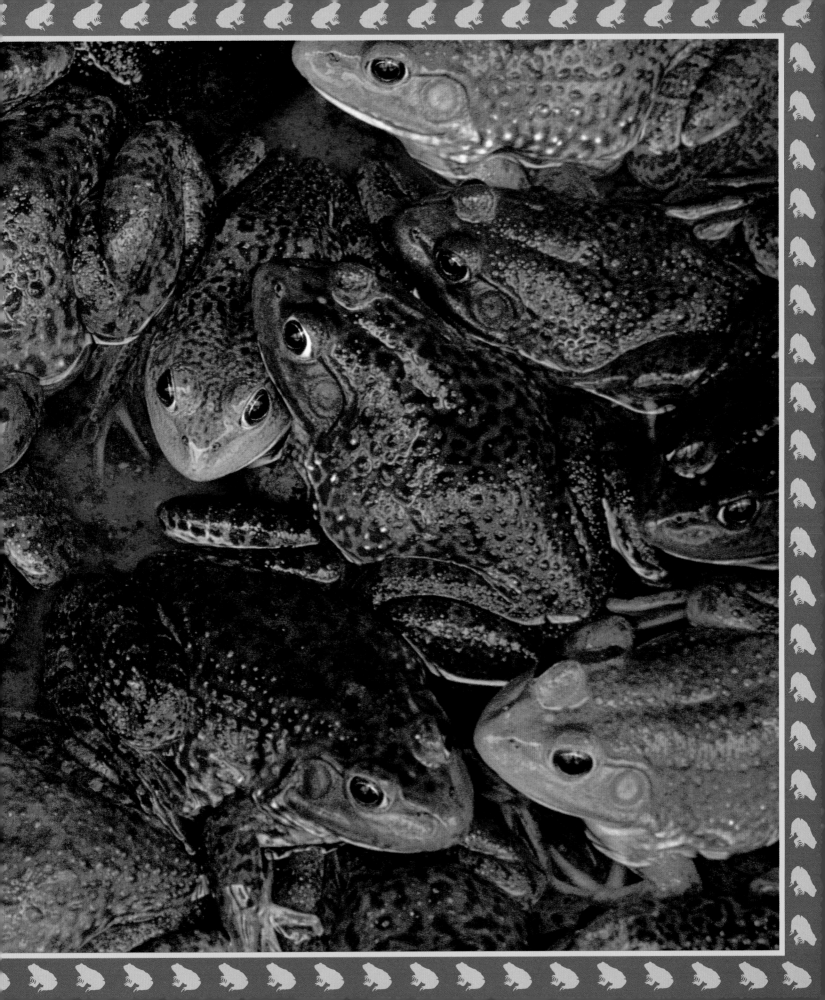

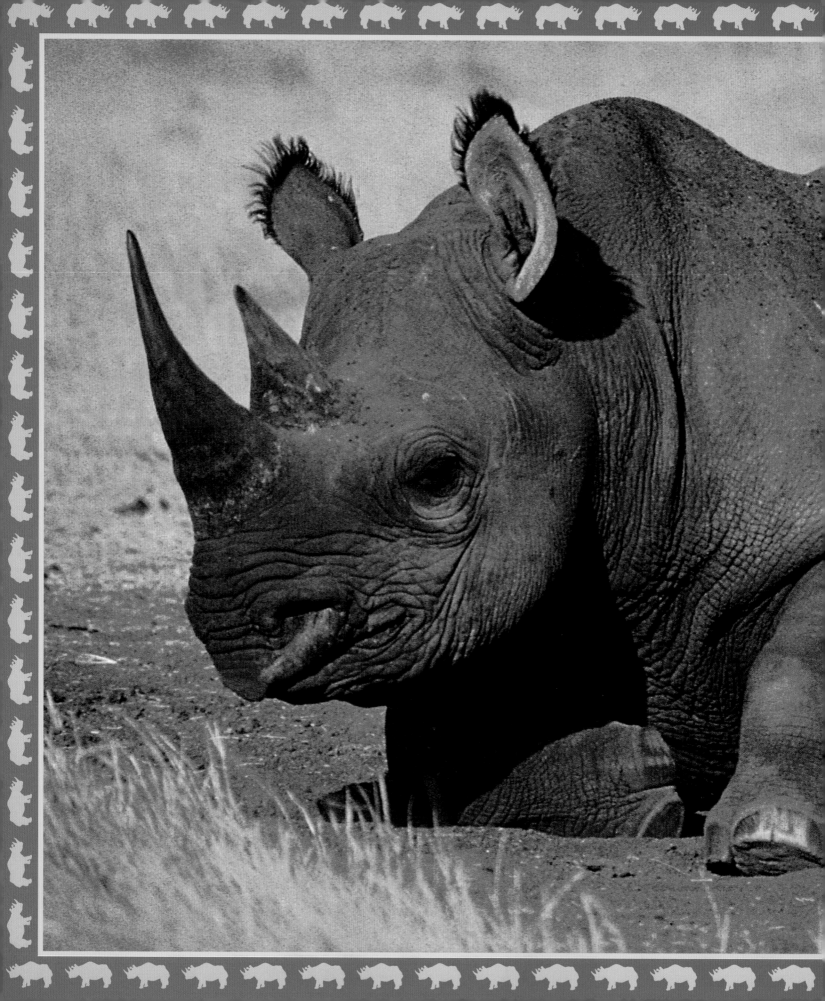

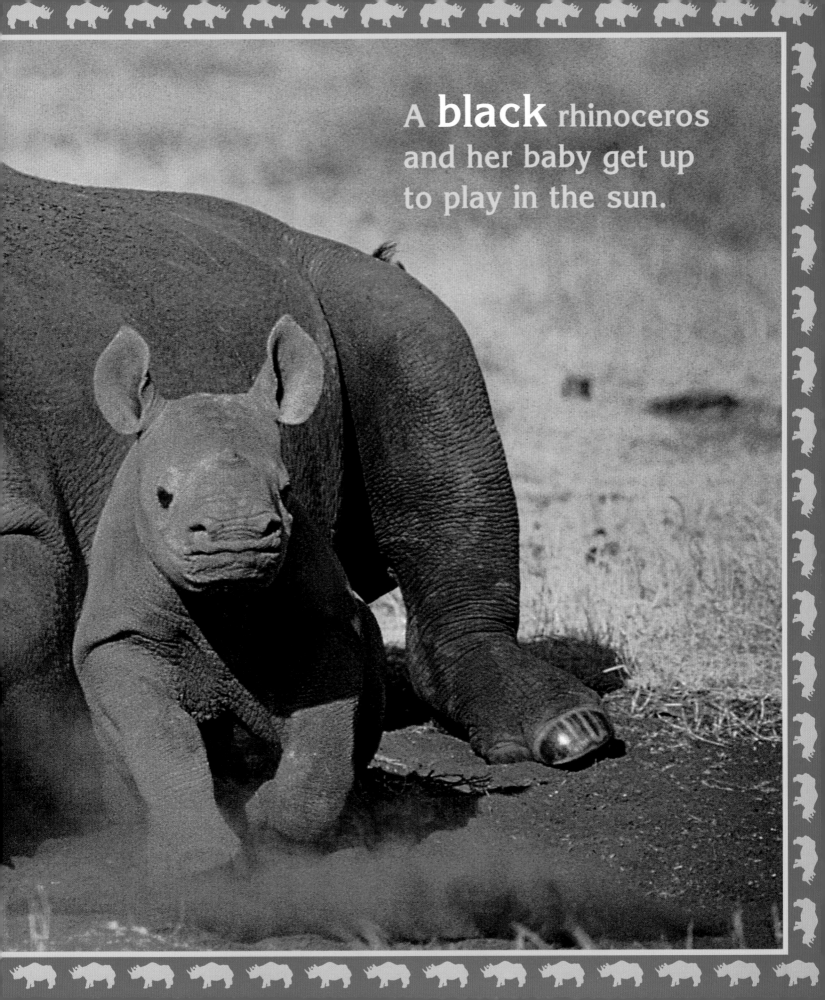

A **black** rhinoceros
and her baby get up
to play in the sun.

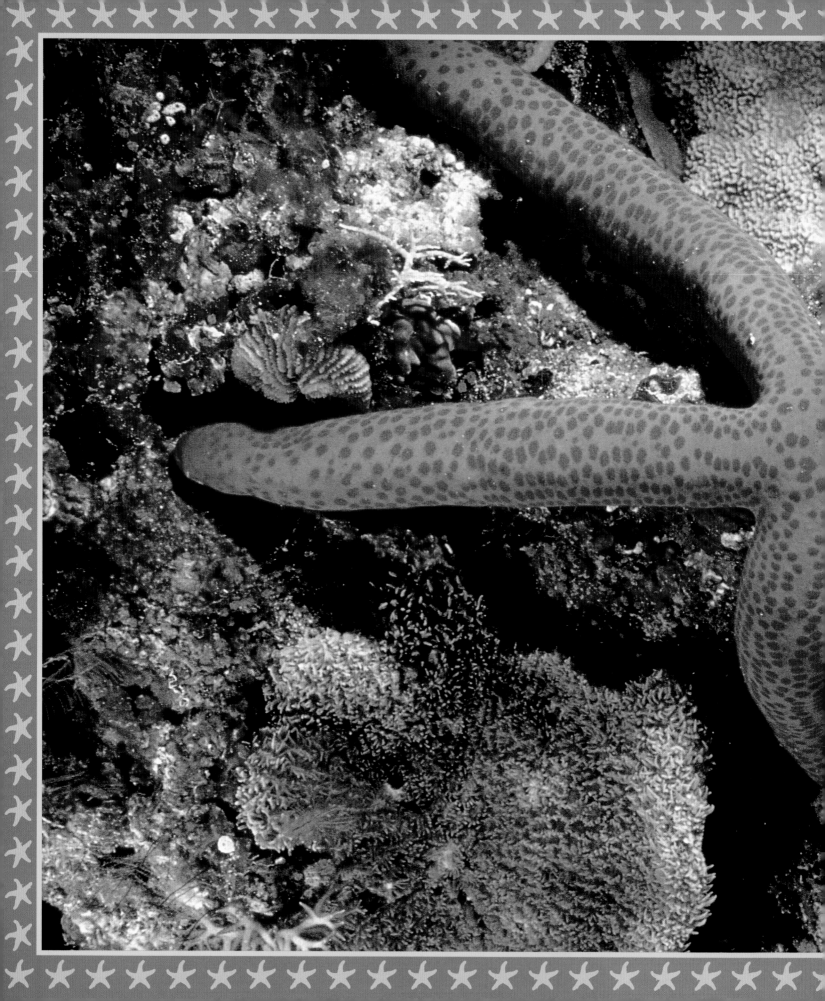

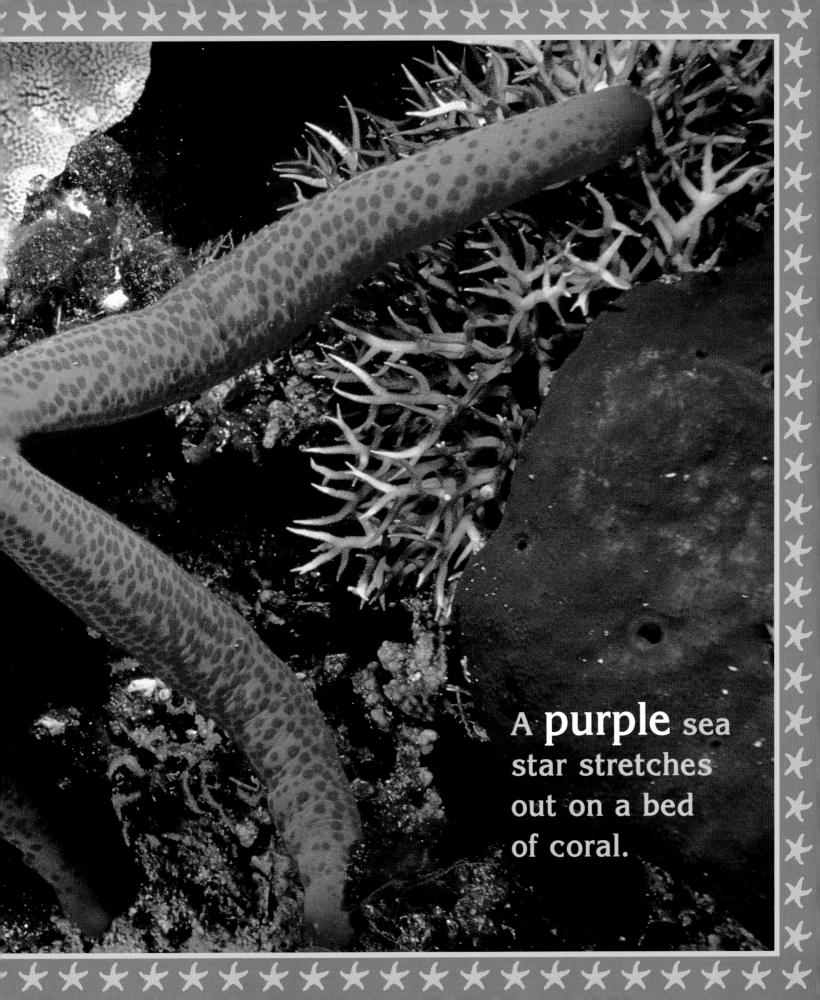

A **purple** sea star stretches out on a bed of coral.

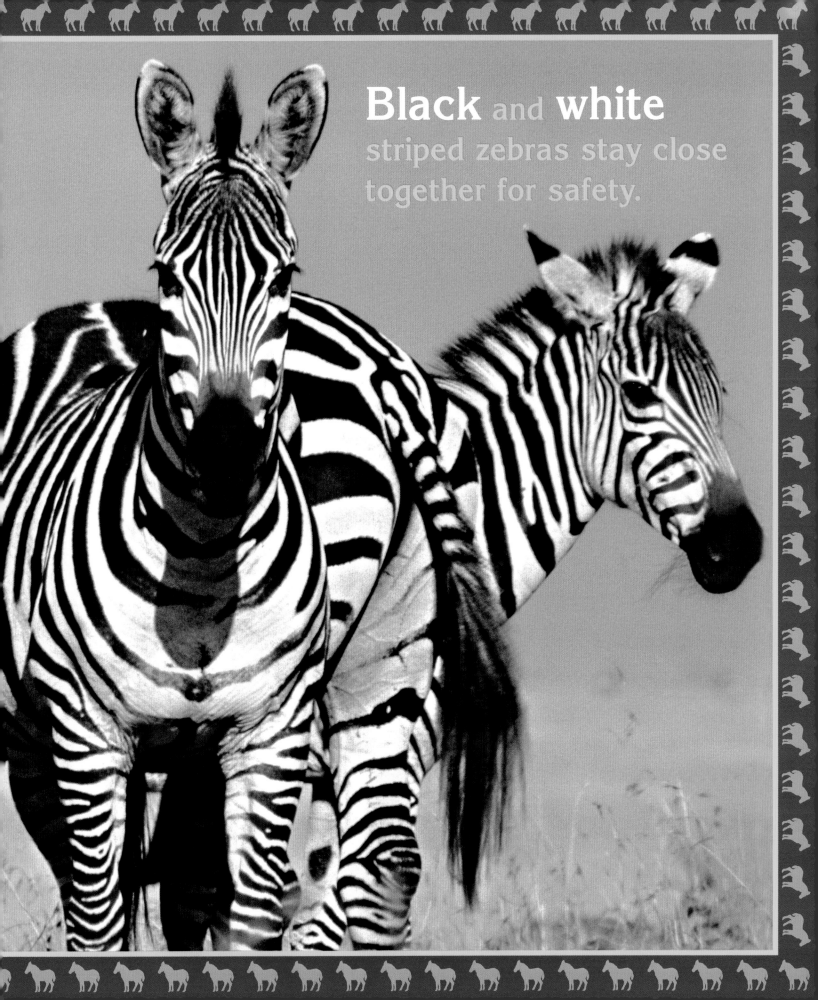

Black and **white** striped zebras stay close together for safety.

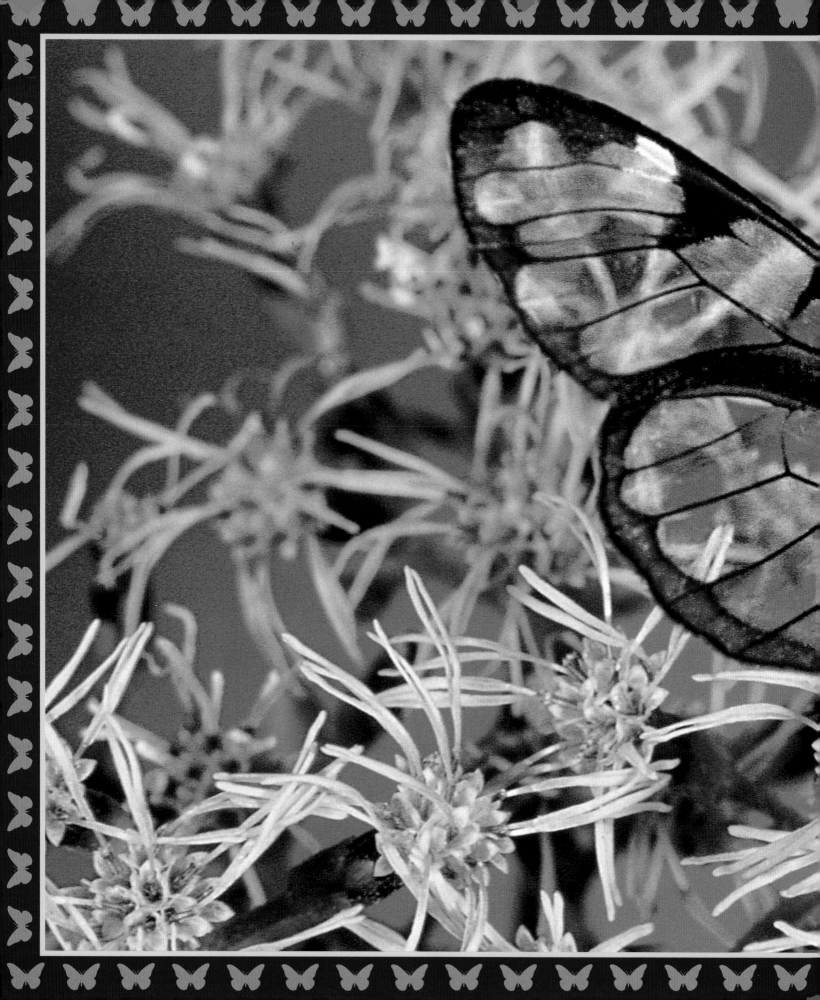

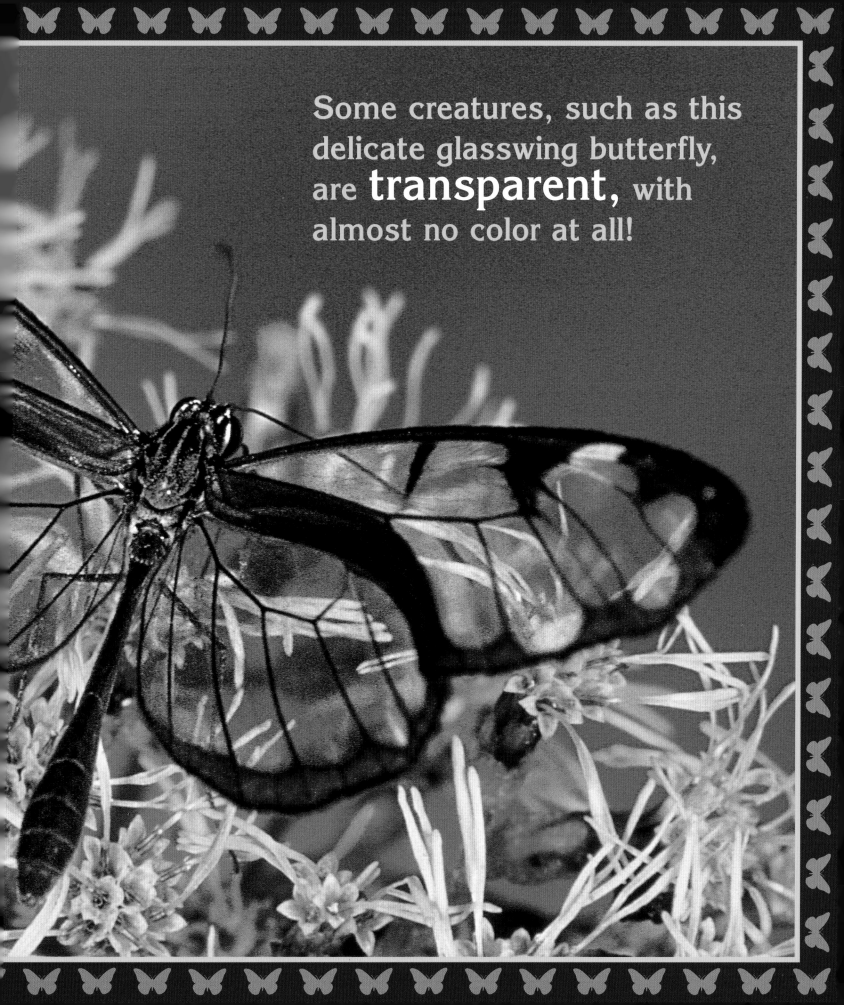

Some creatures, such as this delicate glasswing butterfly, are **transparent,** with almost no color at all!

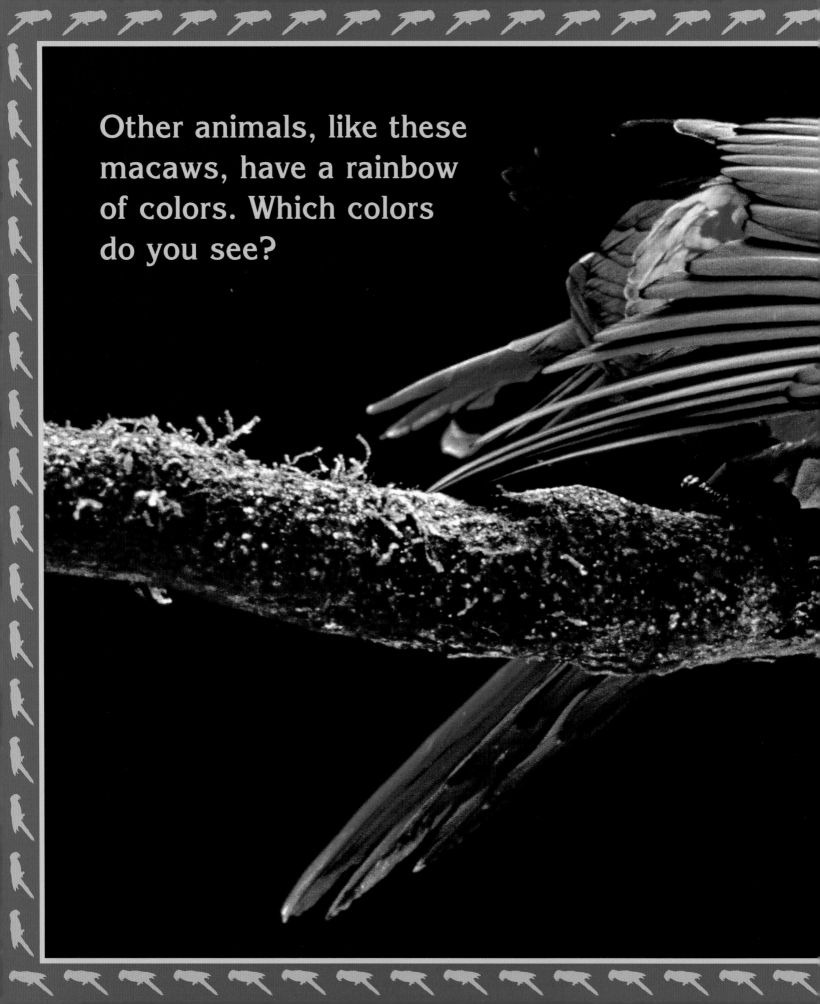

Other animals, like these
macaws, have a rainbow
of colors. Which colors
do you see?

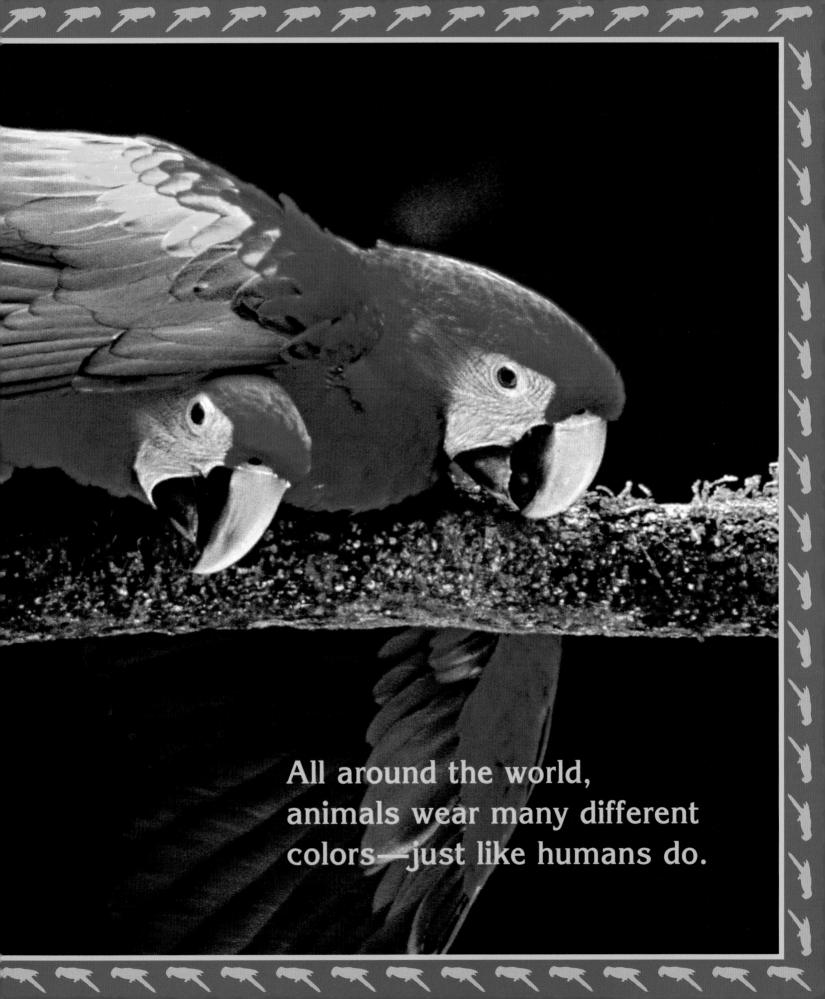

All around the world,
animals wear many different
colors—just like humans do.